A Rendezvous with Renoir

Created and written by
SIMA LEVY

Illustrated by
Justin Morcillo

Mothers Art World
New York

Renoir's Images Provided By
Collection/Bridgeman Art Library

Copyright © 2014 Sima Levy

All rights reserved. No part of this publication may be reproduced, stored in a retrieval system, or transmitted in any form or by any means electronic, mechanical, photocopying or otherwise, without the prior written permission of the publisher.

ISBN: 1494924587
ISBN-13: 9781494924584

Published by
Mothers Art World, Inc., New York
www.Mothersartworld.com

*In Loving Memory of
my hero, my father, Jorge Samouh*

Summary

Ms. Simone's art class is studying the life and works of the impressionist artist, Pierre-August Renoir. Mary is fascinated with Renoir's paintings of cafés and outdoors sights. She wishes to meet with Renoir and his friends in France, to capture her own Parisian scenes and truthful moments.

Together with her friend Manet, they say the magic word three times: "Wackadoey, wackadoey, wackadoey," and then away they blow to the past to meet Renoir in Montmartre, Paris France. The artist teaches them how to capture snapshots of real life quickly, with fluid brush strokes before the moment and light is lost. Mary and Manet also learn how the artist observes and paints flickering lights, children, women and very happy folks.

Mary returns to her art class and paints what she observed in France. To her illustration, she adds her friends Renoir and Manet, in a candid position. The outcome is superb!

Read A Rendezvous With Renoir and you will experience a "Manet Day," learn to use your imagination to improve your art, and feel coo-cooey wackadoey. So what do you say?

Song: "Cool and Carefree." Lyrics by: Sima Levy.
Music by: Cory Dibona and Peter Scarlata.
Performed by: Jordan Levy, Logan Levy, Paris Levy and Peter Scarlata.

Song available on www.mothersartworld.com

I dedicate <u>A Rendezvous with Renoir</u>, to my inspirations and muses. My children and love of my life, Jordan, Logan and Paris, my supportive husband Jason and supermom Judy!

Acknowledgements

First, I would like to thank my wonderful husband Jason, for believing and supporting my vision. My loving children Jordan, Logan and Paris for inspiring me to write characters that remind me of their personalities, and for always wanting to listen to my ideas and share their opinions.

Thank you to my beautiful mom, for always encouraging me to be the best that I could be and to follow my dreams.

Thank you Cohen's Medical Center, of the North Shore-LIJ Health System, for allowing me to share my knowledge and passion of art history, which can be intimidating to children. My goal is to eliminate that factor and teach in the way that is entertaining, informative and interactive.

Much thanks to Ann Marie DiFrancesca, Randee Bloch, Megan Thompson, and the rest of the Child Life staff who amaze me every time that I visit.

Thank you Dr. Cindy Dolgin and Cantor Marcey Wagner, for giving me the opportunity to teach art appreciation, at Schechter Day School. My students are amazing, knowledgeable and creative. I'm fascinated by how they observe information and with the way they view art. I teach with honor and great zeal!

Most importantly, I want to thank G-D for giving me the opportunity to give back to others. Thank you for your guidance as I am and we all are your children.

Buzz, buzz, buzz! The alarm is hounding.
"Good-bye, sweet dreams," it's sounding.

Time to get ready; adventures await.
So hurry up! Get moving! You can't be late!

"Paris," Mom calls, "don't forget your art supplies."
"I'm packing them now," she replies.

Off to school, to join her friend Mary.
She can't wait to begin the day of imaginary!

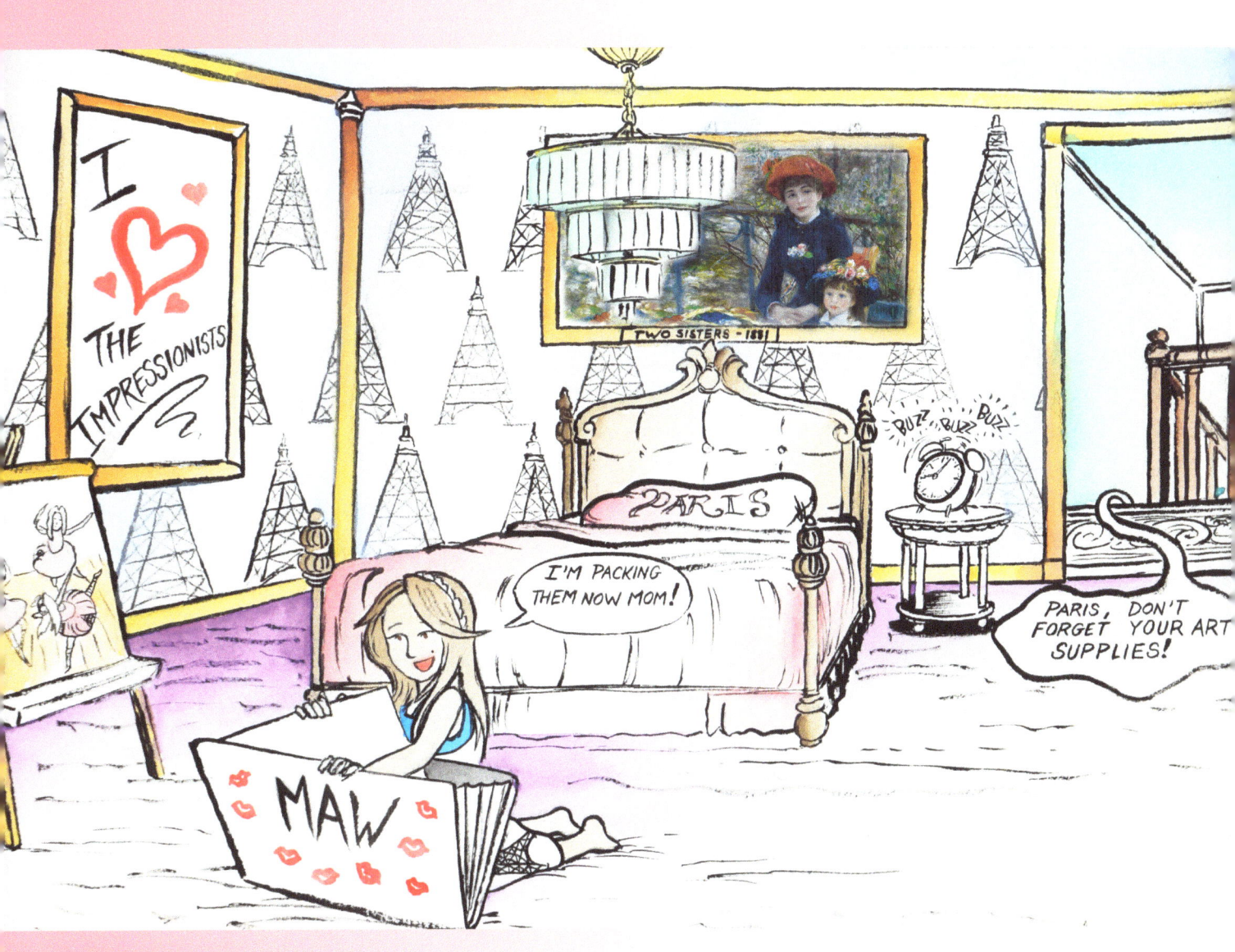

Paris and Mary are chatting on their way to school.
Mary notices that Paris is wearing a golden jewel.

"Wow, Paris," says Mary, "I love your new sparkly chain."
"Its a gold Eiffel Tower," Paris explains. "It's pretty and plain!

I'm looking forward to today's art class.
We'll be celebrating Renoir - at last!

In honor of the French artist,
I'm sporting my new necklace.
My mom said I could wear it during recess,
so long as I'm not reckless."

Mary says, "I also brought something in honor
of Monsieur Renoir:
A piece of ceramic from Limoges, France;
it's a gift from my grandma."

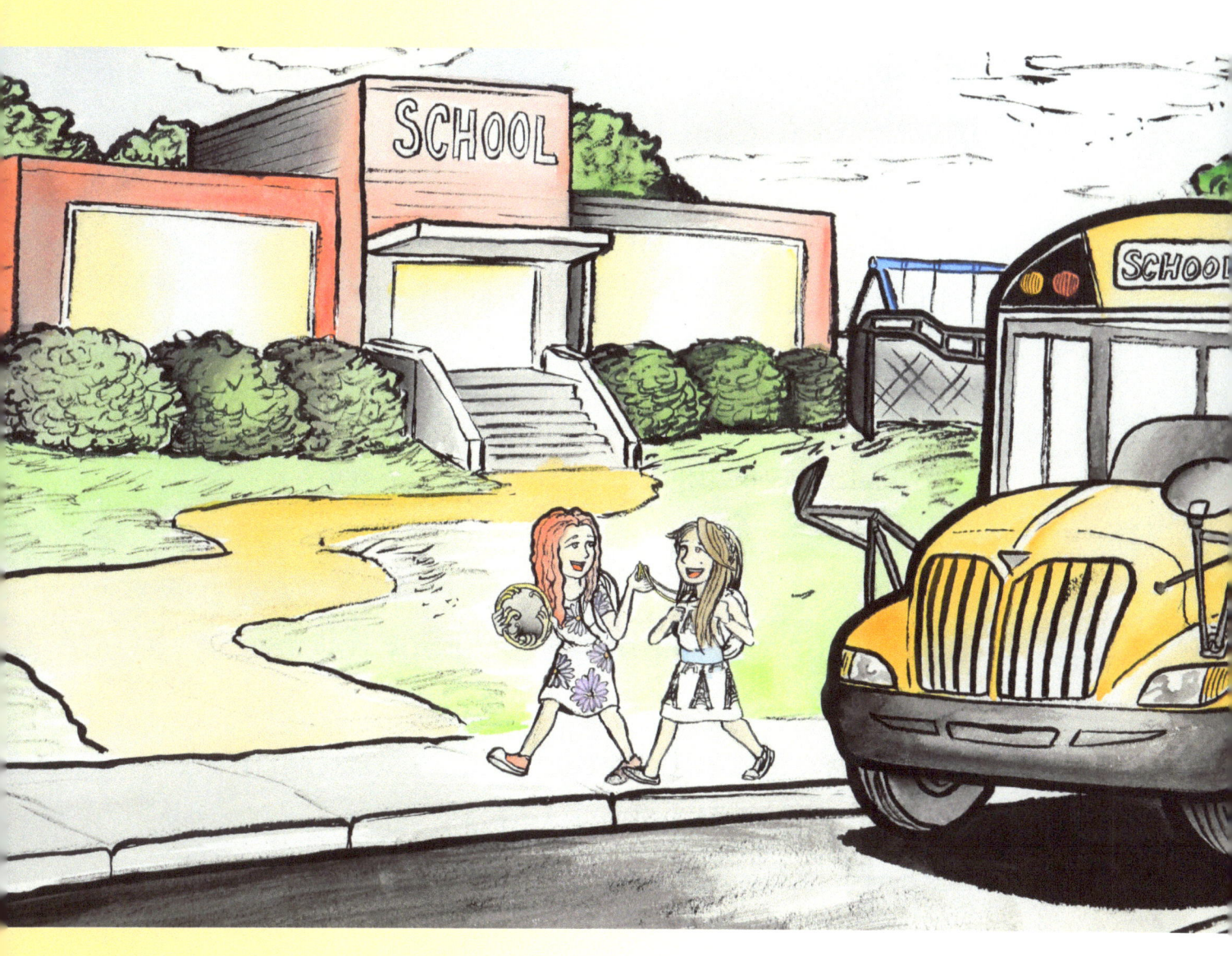

Ms. Simone:

"Welcome, girls and boys, to Art Appreciation.
Our artist of the day is from the French nation.

Pay attention carefully, everyone:
Pierre-August Renoir was born in 1841.

In Limoges, France, a place where
Artists made magnificent dinnerware.

Defined by his quick brush strokes,
Light colors and paintings of happy folks.

He was a creative and productive Impressionist painter,
Who illustrated along with Pissarro,
Sisley and Monet, his trainer."

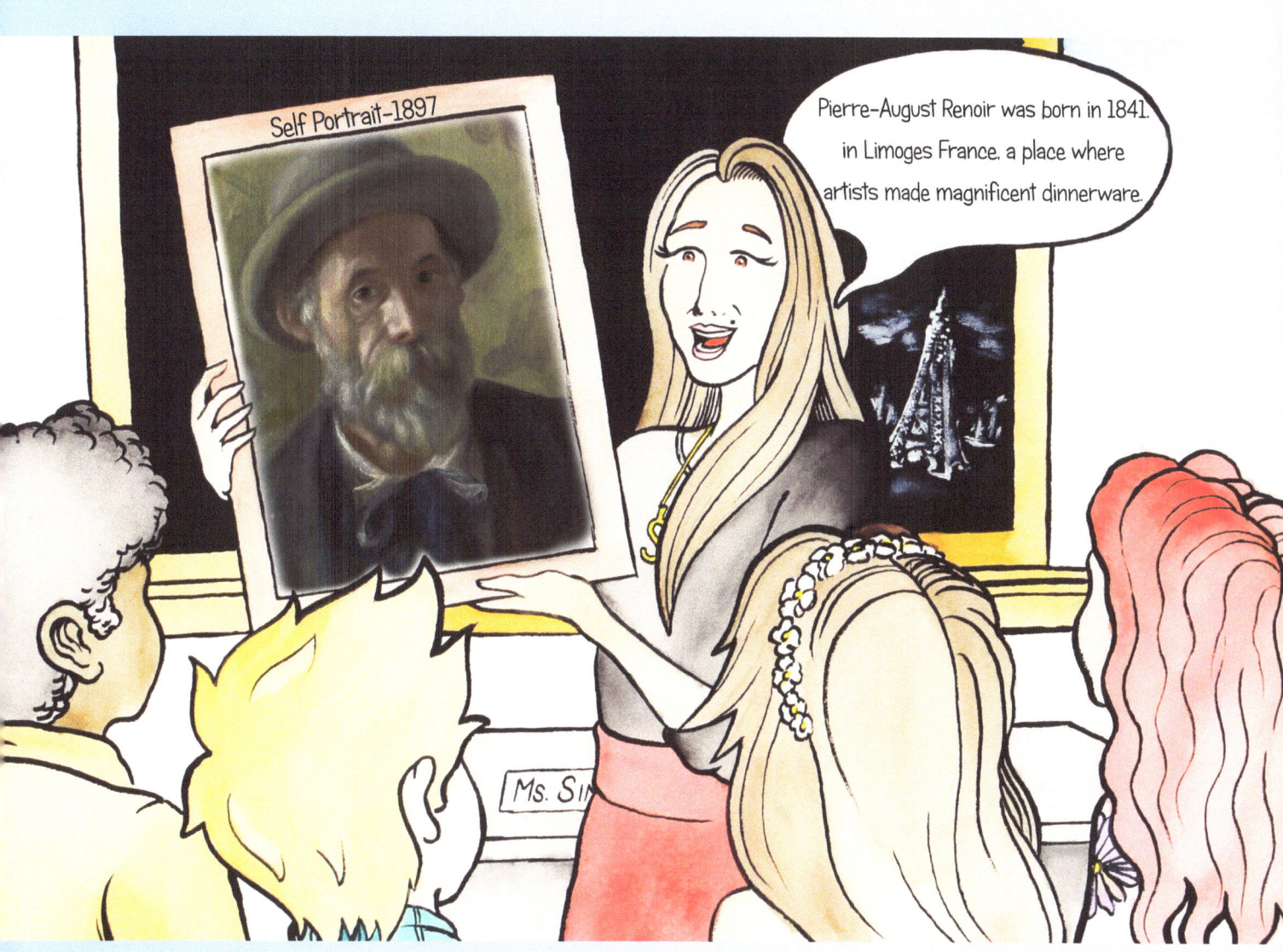

Mays asks, "What is Impressionism?"
Ms. Simone replies, "Impressionists avoided perfectionism.

Using their talents to capture the everyday:
A beautiful landscape or a scene from a café.

Renoir painted what was happening at a giving moment,
Not the thing that last forever, but a scene of enjoyment!

The artist was well known for his illustrations of pretty flowers.
Happy settings, children and women, gave his art powers!

Often, he was found painting
on the banks of the beautiful Seine River.
Boating on the Seine reflected light in shimmery silver.

At the Louvre, he studies classic art works, when he was training.
He mixed classic and impressionistic art, as his styles was changing."

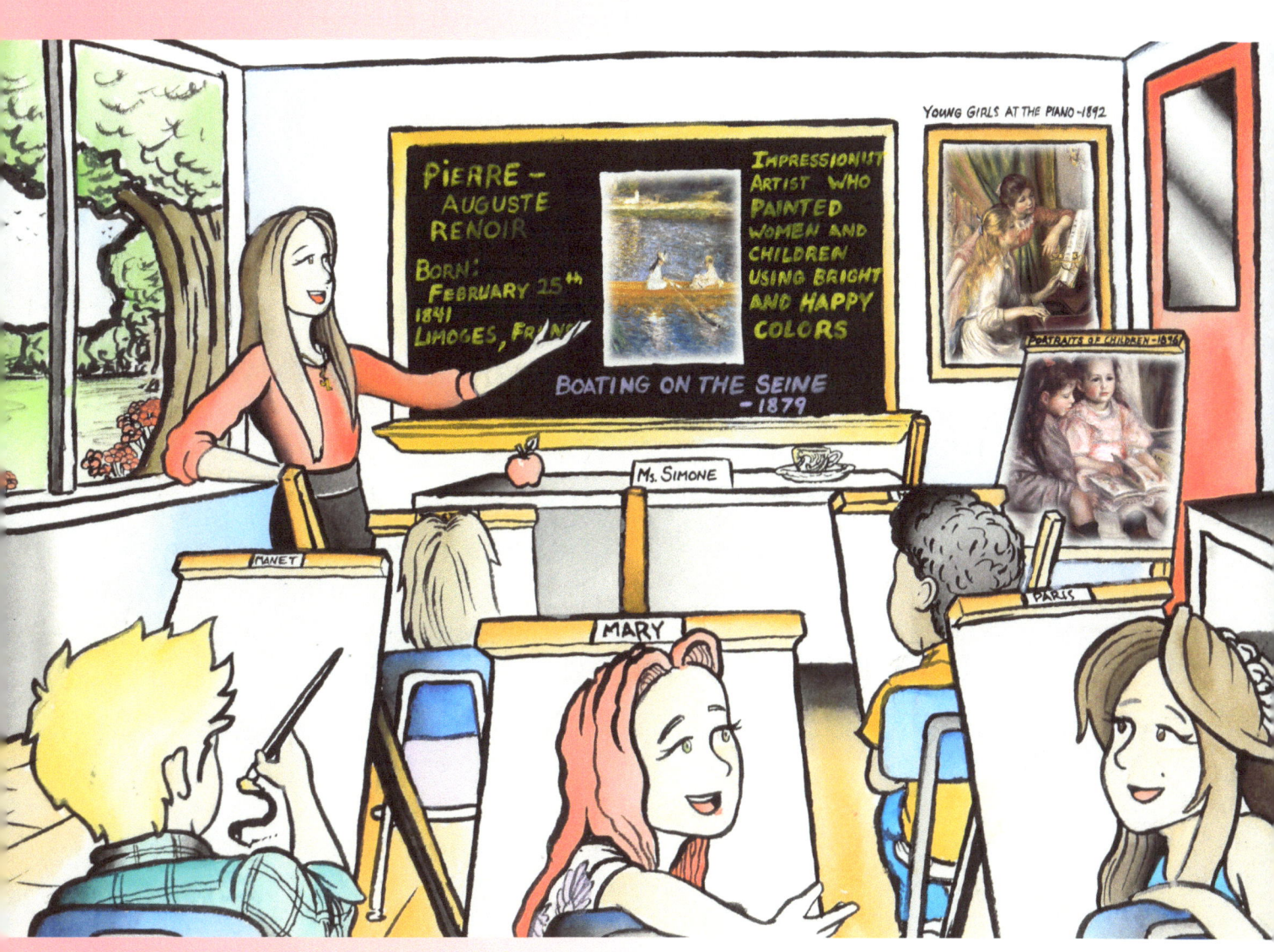

Mary asks, "Ms. Simone, when did Renoir
realize that he was interested in art?"
Paris adds, "When did it all start?"

Ms. Simone replies, "Renoir developed
a strong talent for drawing as a child.
Working in a porcelain factory, fine china he had styled."

"He was a young artist just like us!" says Manet.
Justine whispers, "maybe, we will be famous artists one day."

Ms. Simone smiles and says, "It's probable.
What do I always say is possible?"

Together the children reply in a joint tune:
"Be the sun reflecting positive energy
and always reach for the moon!"

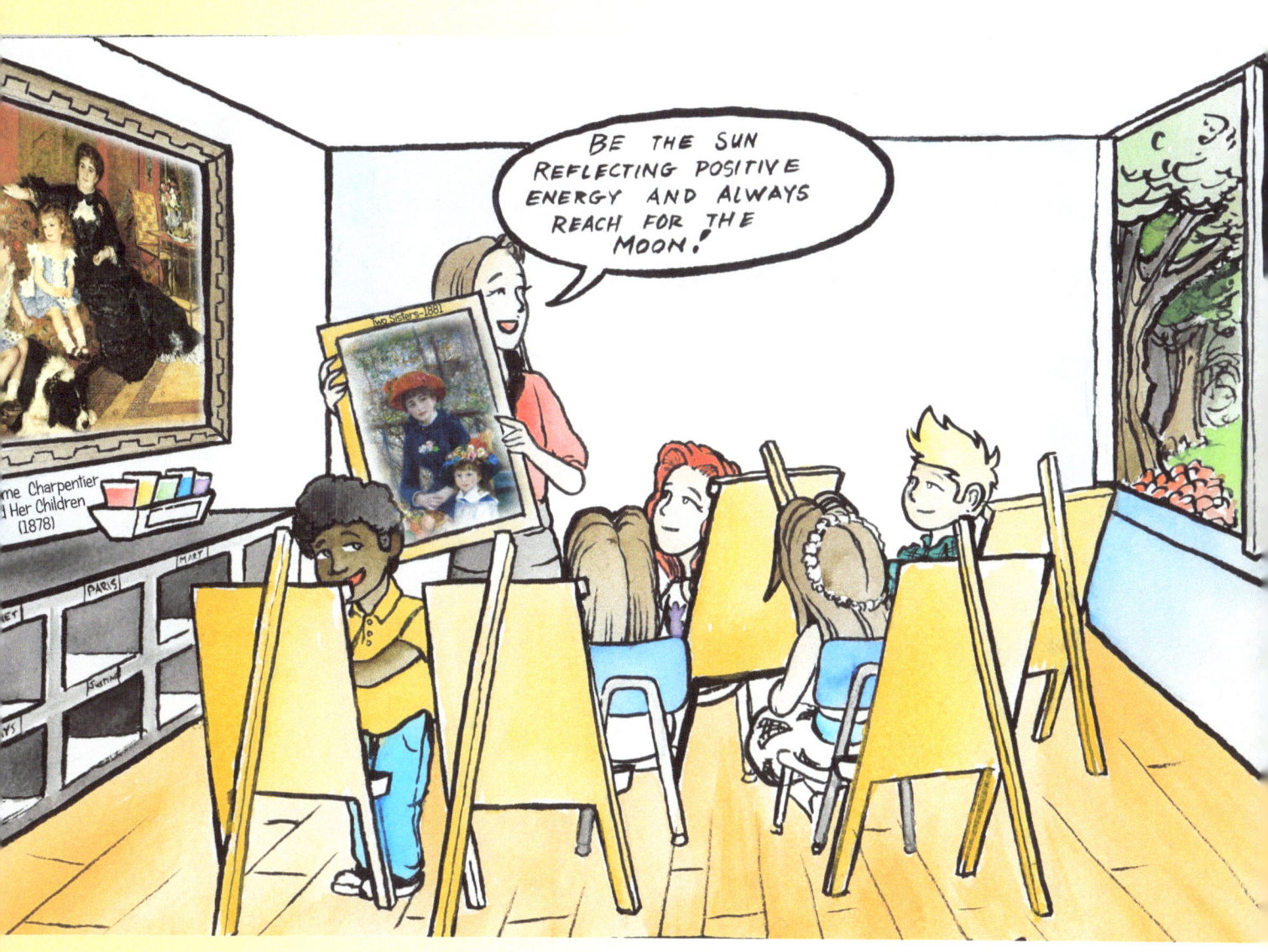

Renoir's style, Mary imitates:
With vivid colors she illustrates.

She wants to capture Renoir's Parisian scenes,
Just like she's seen in books and movie screens.

Her wish is to meet with Renoir and his friends in France,
To paint an outdoor scene - and she might just get the chance.

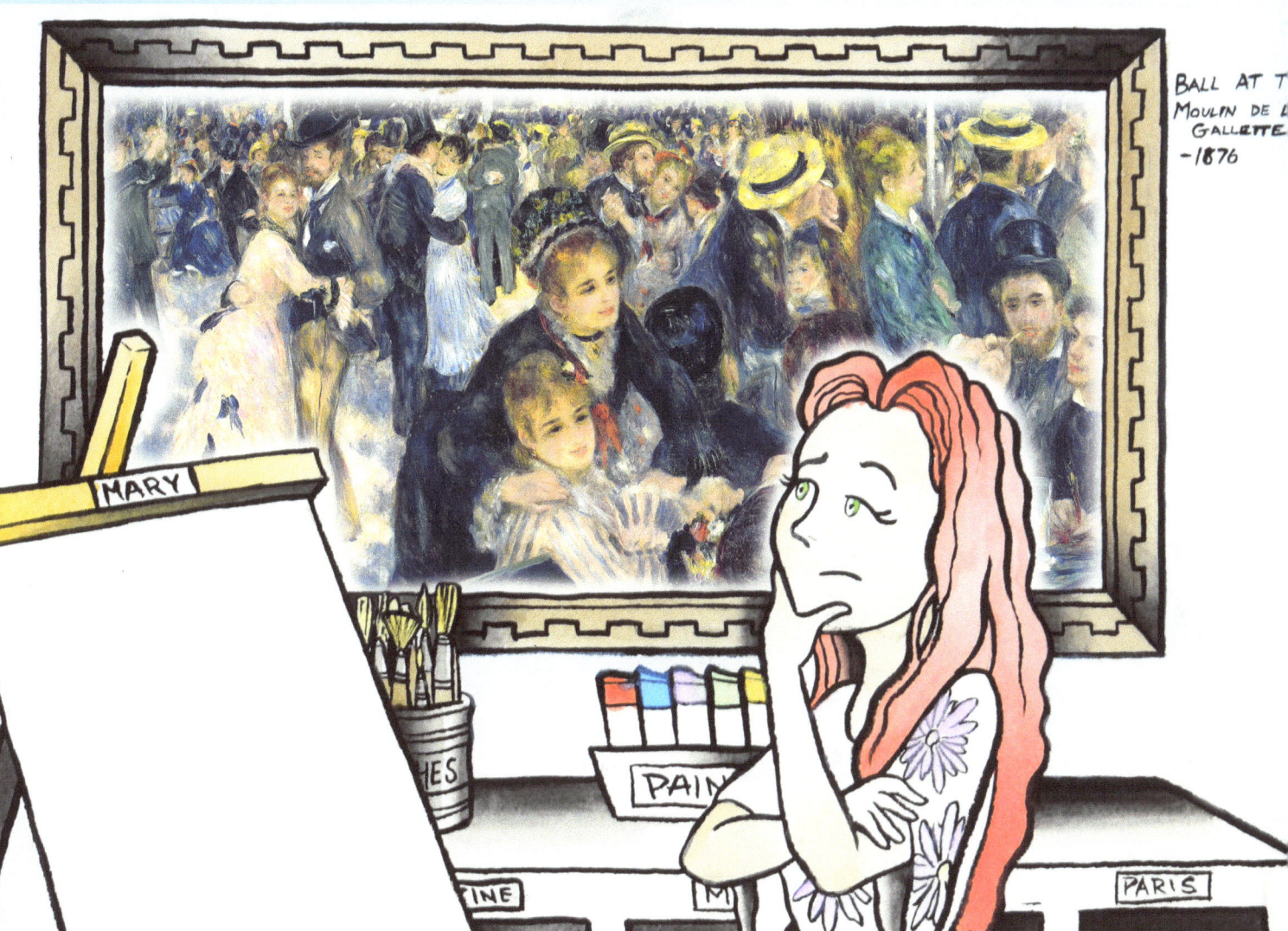

"Hey Manet," says Mary, "I wish to paint a genre,
A piece from everyday life, but how can I capture the drama?

Please teach me your ways, so I can learn if I may.
I would like to have a rendezvous with Renoir and spend the day."

Manet looks amused as he scratches his head.
He finally asks, "Has my secret spread?"

"Not sure what you mean?" says Mary.
"Sometimes you seem dreamy and a bit airy;

But how is it that your paintings are always so pretty,
Happy, perfectly illustrated and witty?"

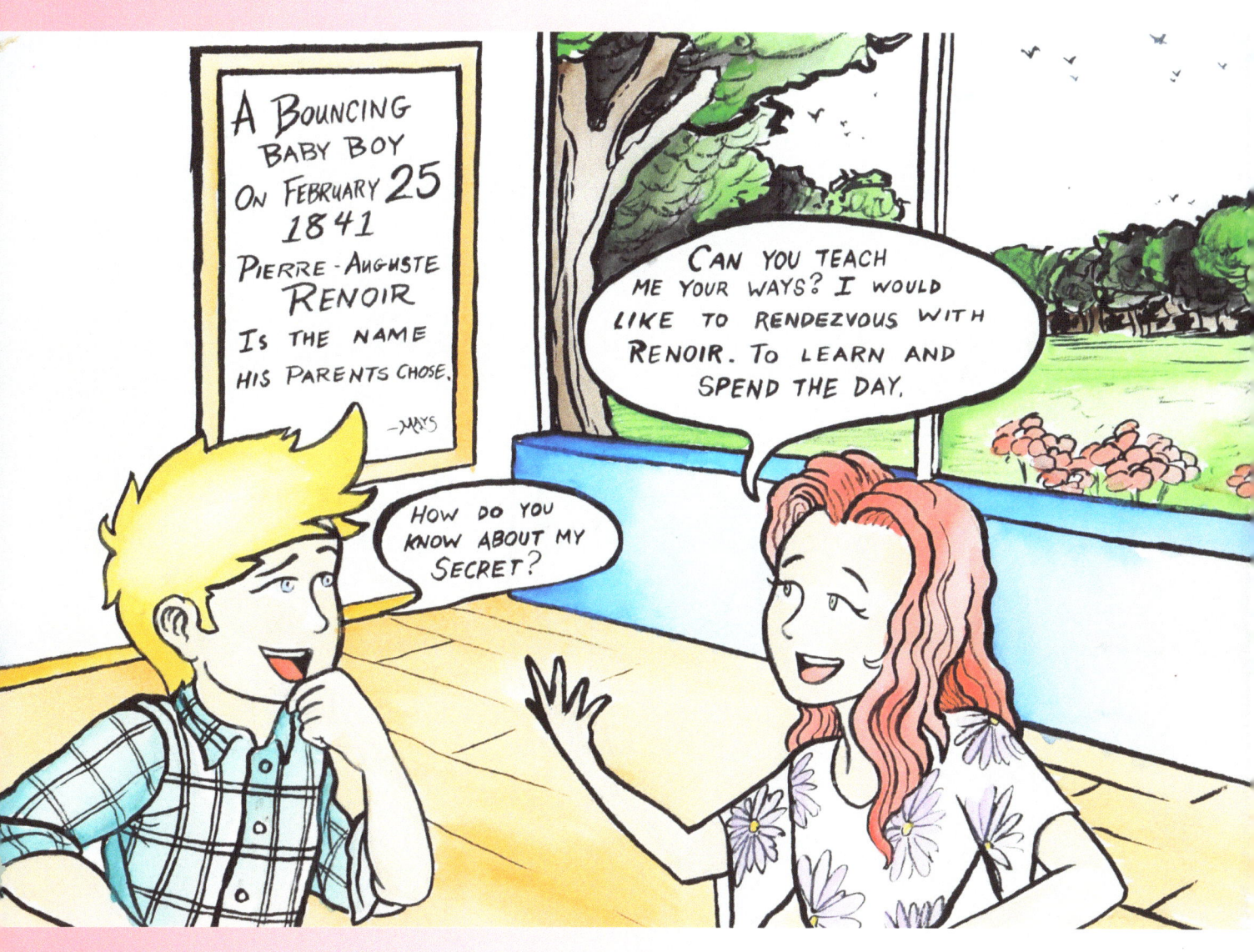

"Mary," says Manet, "Close your eyes and do as I do.
In your imagination, you'll find the missing clue.

Being wackadoey will set you free.
Say it three times and you'll travel with me."

"Wackadoey! Wackadoey! Wackadoey!"
And away they blewy!

They dreamed of him and then - Voilà!
Standing right in front of them was Monsieur Renoir!

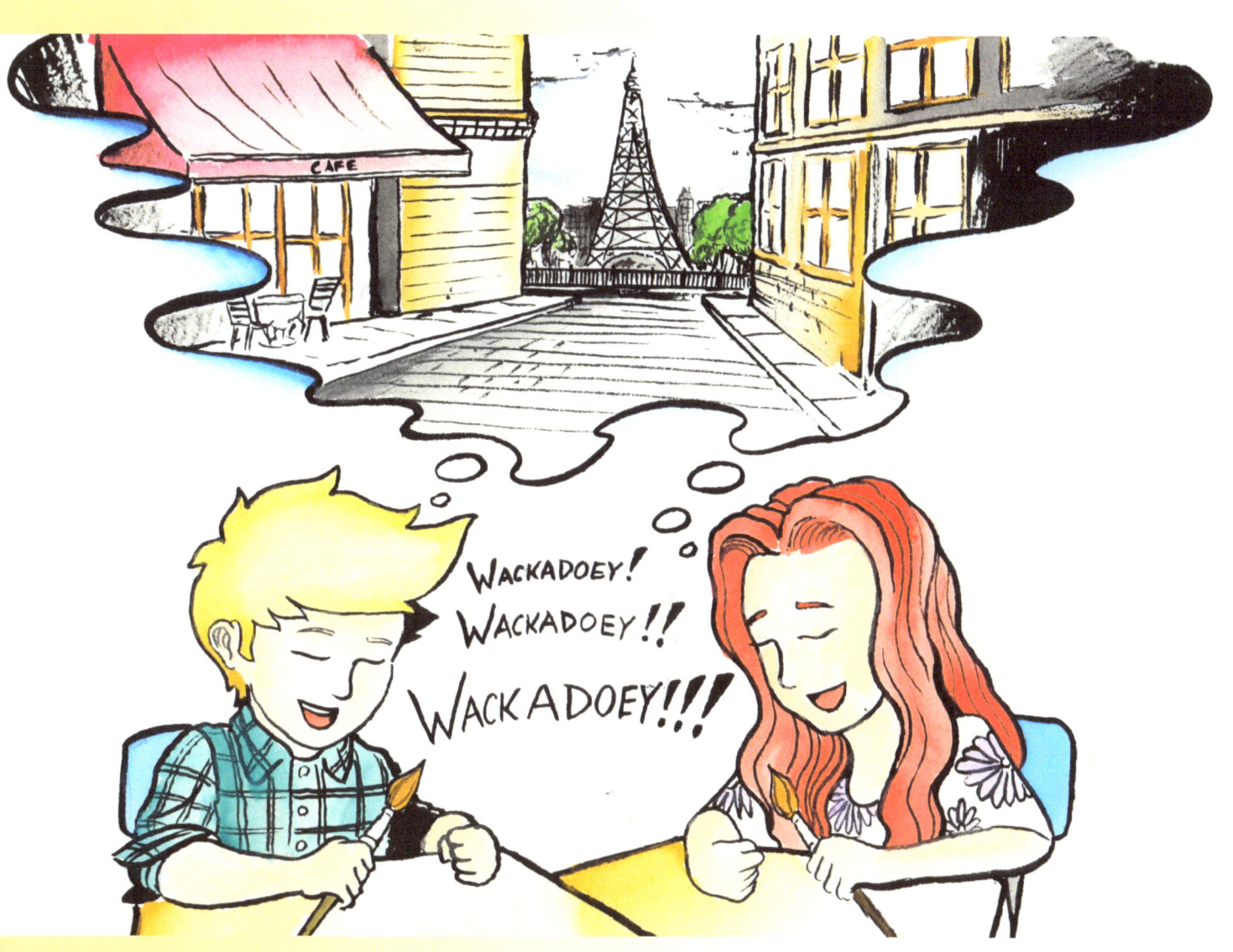

Mary and Manet are in Renoir's most important painting.
The Dance at *Le Moulin de la Galette*, they are both acquainting.

Renoir approaches them and says, "Welcome to Montmartre France.
This is where Parisians get dressed up, eat galettes and dance."

"Merci, thanks Monsieur Renoir," say both Mary and Manet.
"We wish to spend the day. What do you say?"

Renoir replies, "I say qui, why not, yes."
Mary asks, "How did you capture such a huge scene, and fast no less?"

Renoir smiles and replies, "As an Impressionist,
I capture snapshots of real life fast; I'm an expressionist!

Before the moment is lost, I paint with fluid brush strokes,
Flickering lights, children, women and very happy folks!"

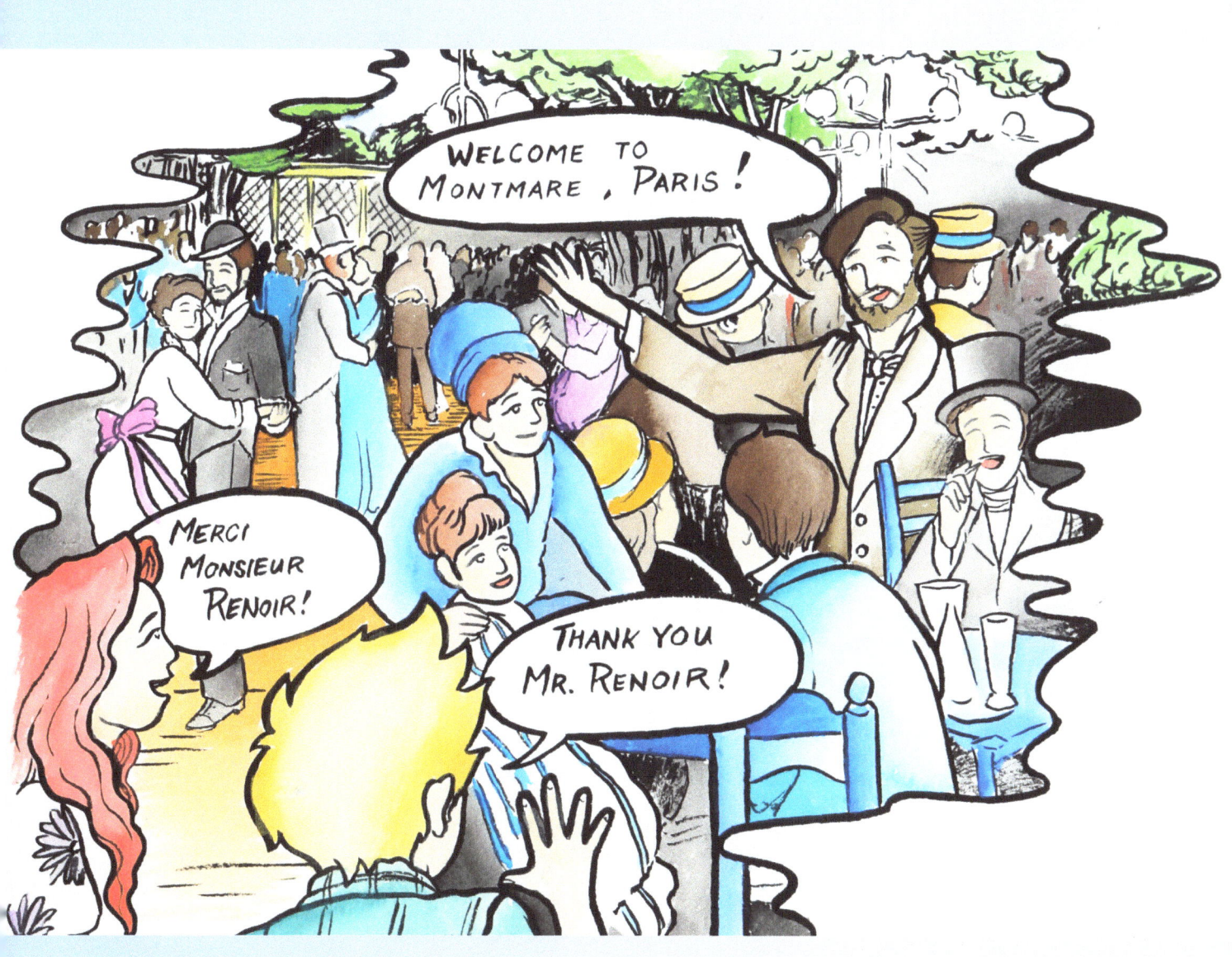

Mary asks, "You think that I can capture a Parisian scene?"
Renoir replies, "Qui, why not?
Simply paint what your eyes have seen.

In the 1860s, I met the *Father of Impressionism* Claude Monet.
I became an Impressionist artist and painted by day.

Sisley, Bazille, Manet and the rest of the "cool and carefree,"
We all produced loose casual paintings, hassle-free.

With the use of short, broken brush strokes that are barely formed.
Thick application of paint, made my art from near look transformed.

Painting people in their natural elements,
I didn't have time to take five.
Stand back to view my painting and you'll see how it comes alive."

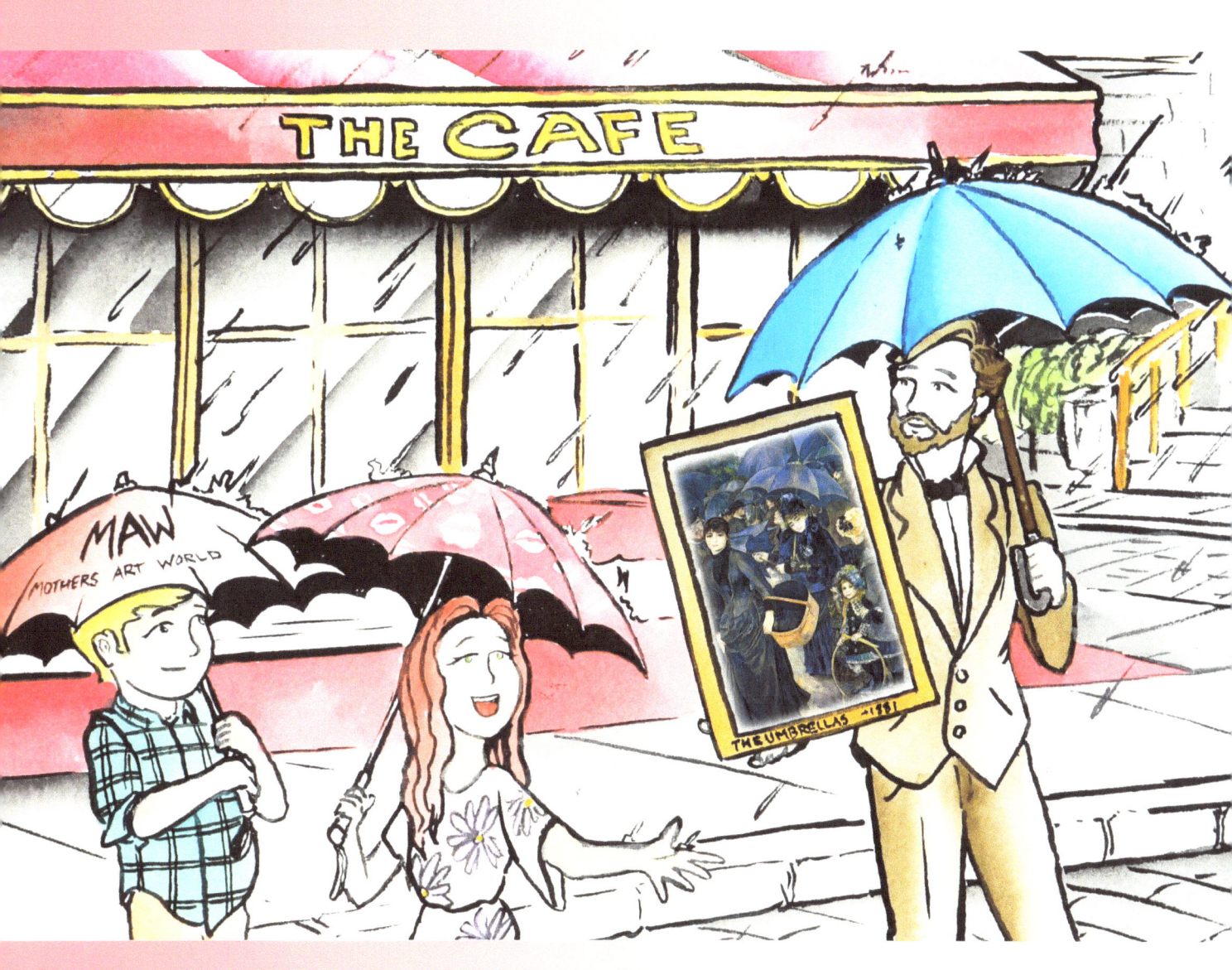

"But Monsieur Renoir, how do I
not loose the moment?" asks Mary.
Renoir replies, "Take your art supplies with you mon chéri.

Focus on the movement of light.
It will make your art colorful and bright.

Capture your buddies in a candid moment.
Your painting will display a priceless component.

Dance at *Le Moulin de la Galette*,
was my most important work of art.
A beautiful afternoon with friends,
that I love with all of my heart!"

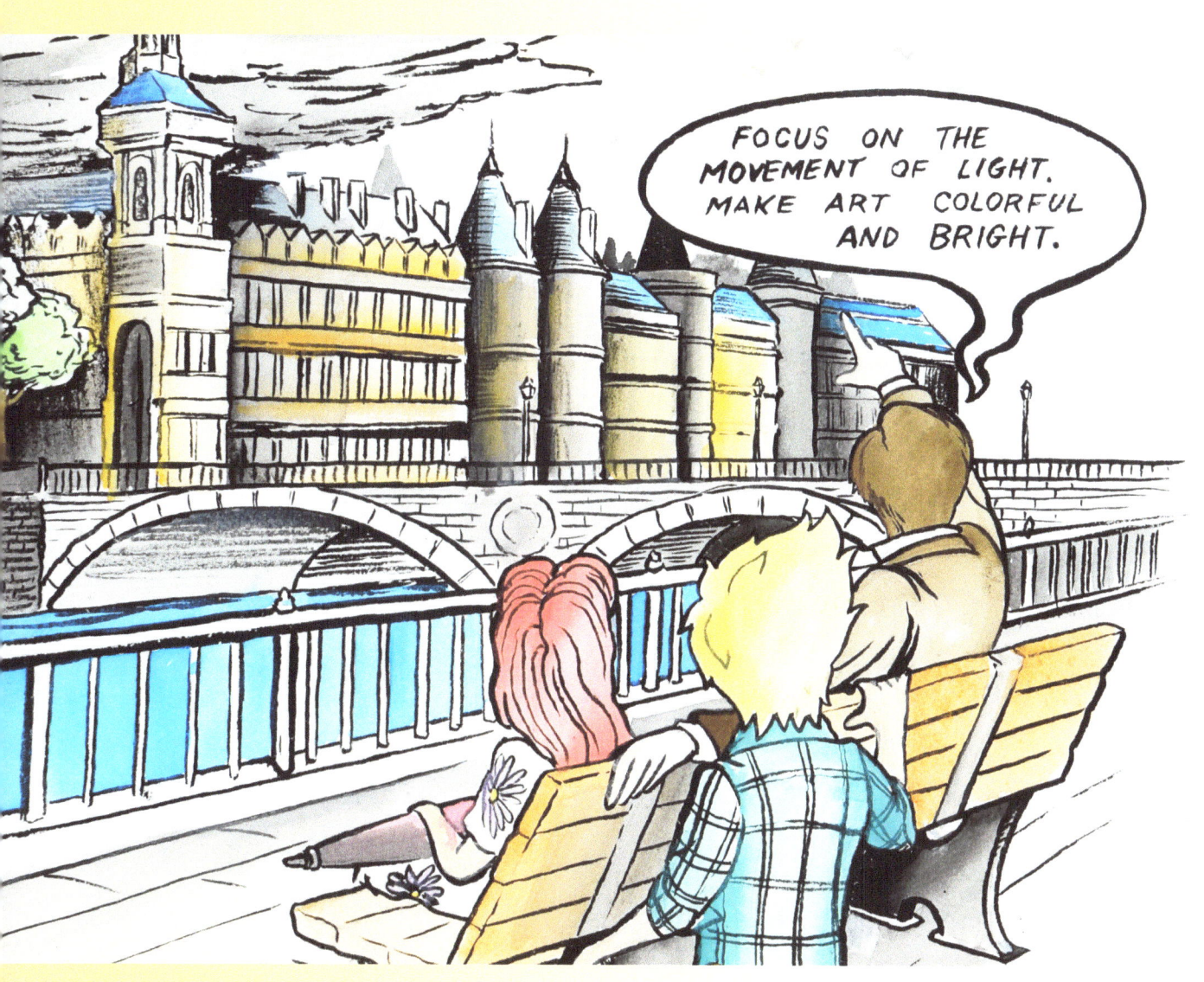

Mary was content and says, "Mr. Renoir I have learned a lot today."
"Galette is a flat French cake, most enjoy with their café au lait.

Dance at Le Moulin de la Galette painting, is considered your best,
But I cannot agree, as I like all of the rest.

You exhibited with the Impressionists three times,
And even at the famous Paris's salon sometimes!

You painted many women knitting.
In By The Seashore, a lady was sitting.

Your art is pretty and cheerful,
With great vibe and now I'm happily tearful!

No two leaves are exactly the same.
Your paintings differ; after all it's all in your name!"

Renoir felt honored and says, "Thank you, mademoiselle Mary.
My rendezvous with you, in my memory I'll forever carry."

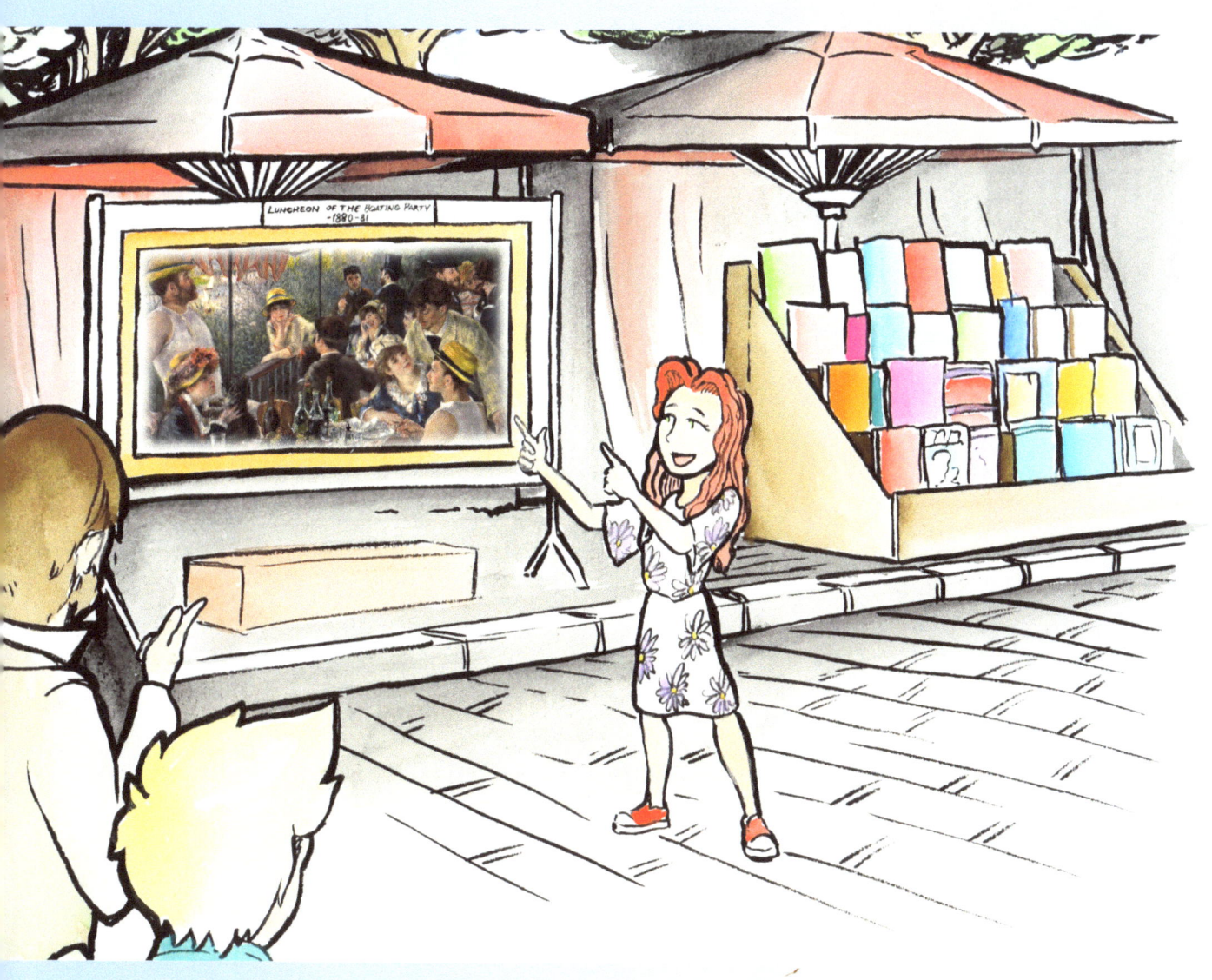

Justine asks, "What's wrong with Mary and Manet?
Their minds seem to be so far away."

Paris whispers, "They are in the land of the artists."
"I don't understand," Mays says, "What land of artists?"

Paris smiles and finally says,
"I'm sure you will both find out one day."
"Great," says Mays,
"but art class is about to end and they cannot stay."

"Earth to Mary and Mays," whispers Justine,
"Come back! Class is ending in fifteen."

"Au revoir," Mary says, "we have to head west.
Thanks Mr. Renoir, you're the best!"

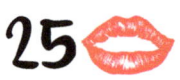

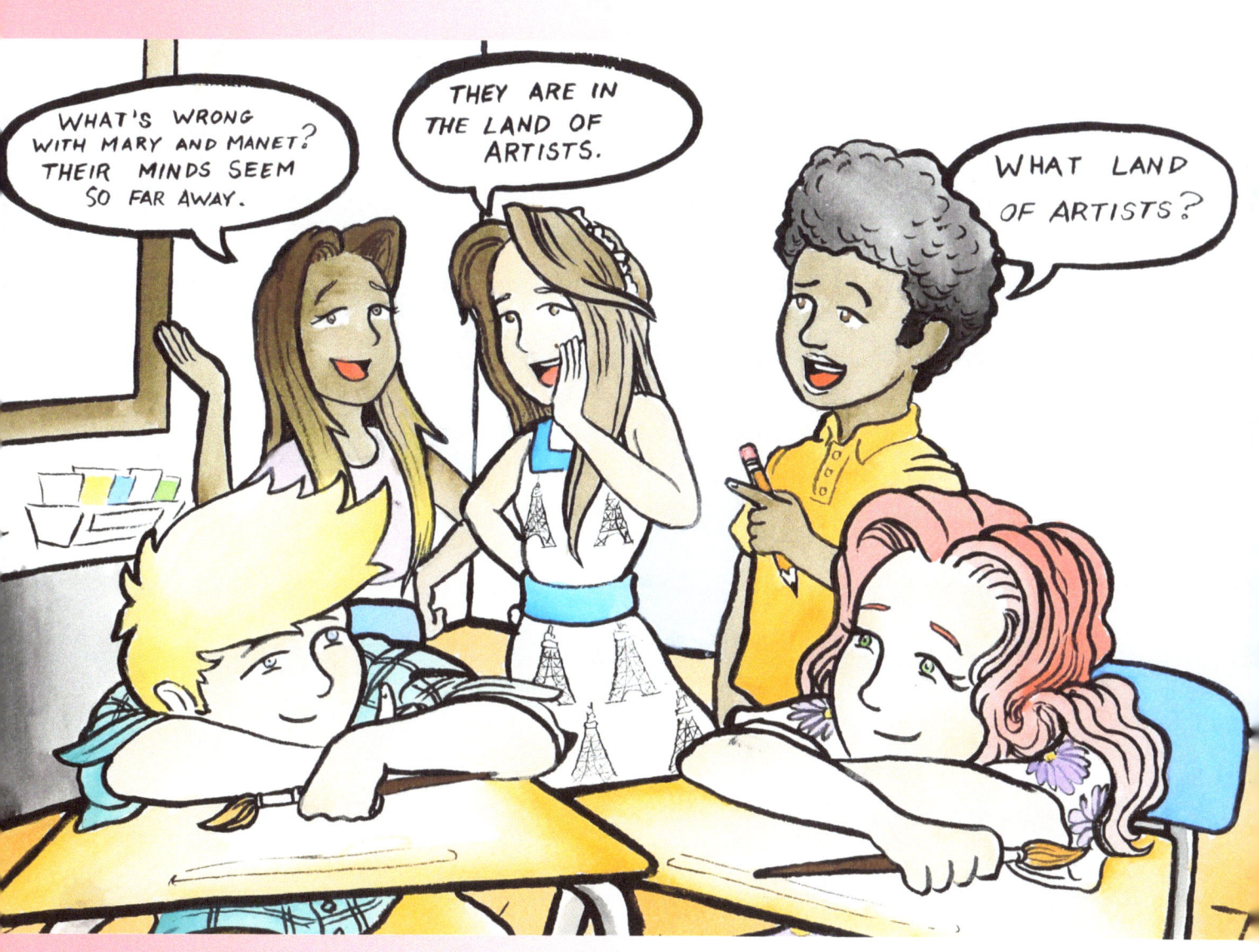

Mary recalls all that she had witnessed
in France and began to compose.
Café's, round small tables,
and Parisian people dressed in fancy clothes.

To the scene, she adds Renoir and Manet in a candid position.
Painting bright and colorful,
following the Impressionists tradition.

Light was shining happy on her canvas.
Ms. Simone says, "Mary, Your painting is precious!

Your art feels alive, I can almost hear music, joy,
People conversing and even laughter, oh boy!"

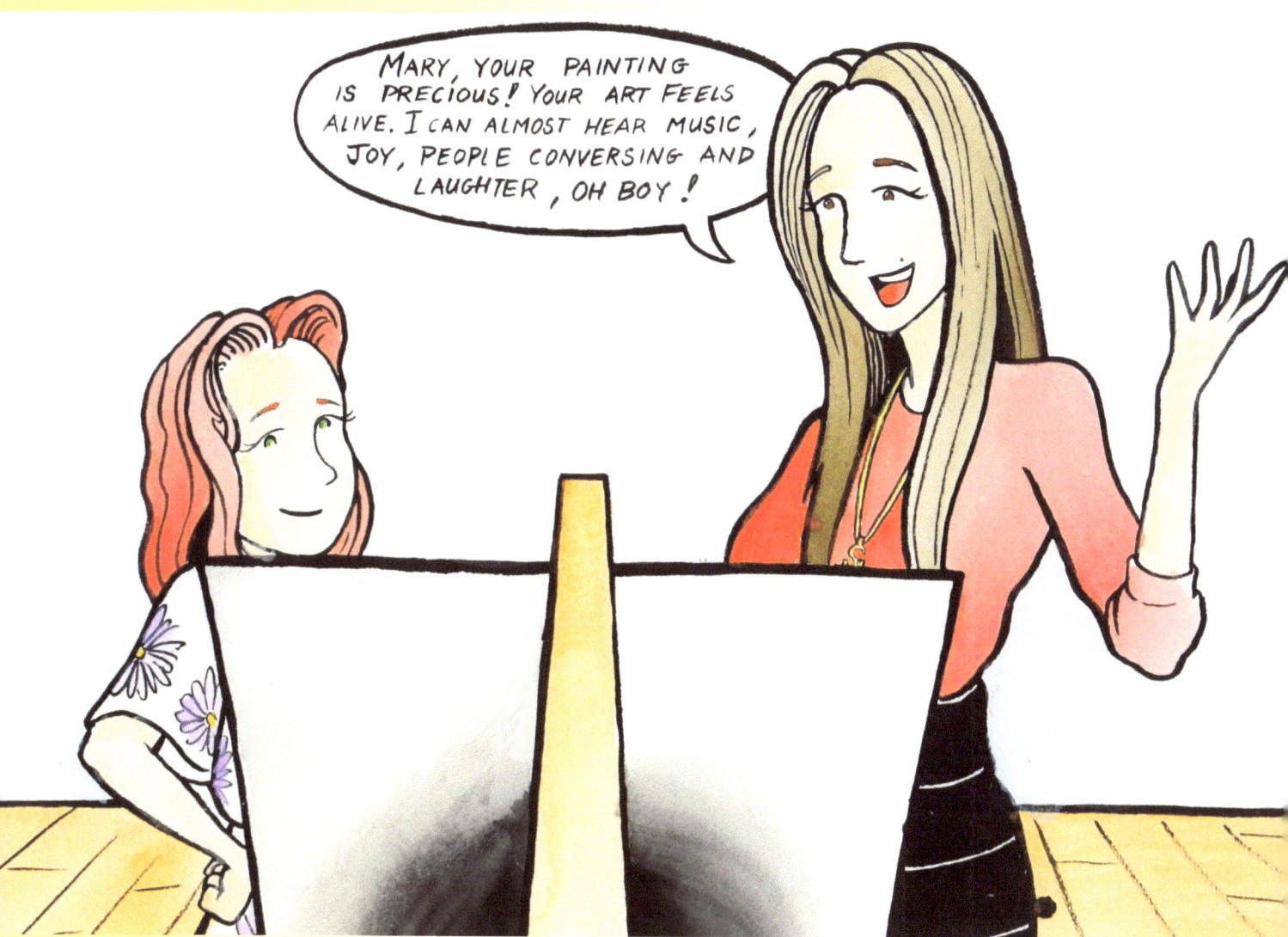

Paris asks, "Mary, how was your meeting with Renoir?"
Mary replies, "Awesome, I can't wait to tell my grandma.

Lets go to Manhattan's central park this Sunday.
We'll paint New York scenes, it will be a fun day!"

Paris excitedly says, "Qui, why not, yes."

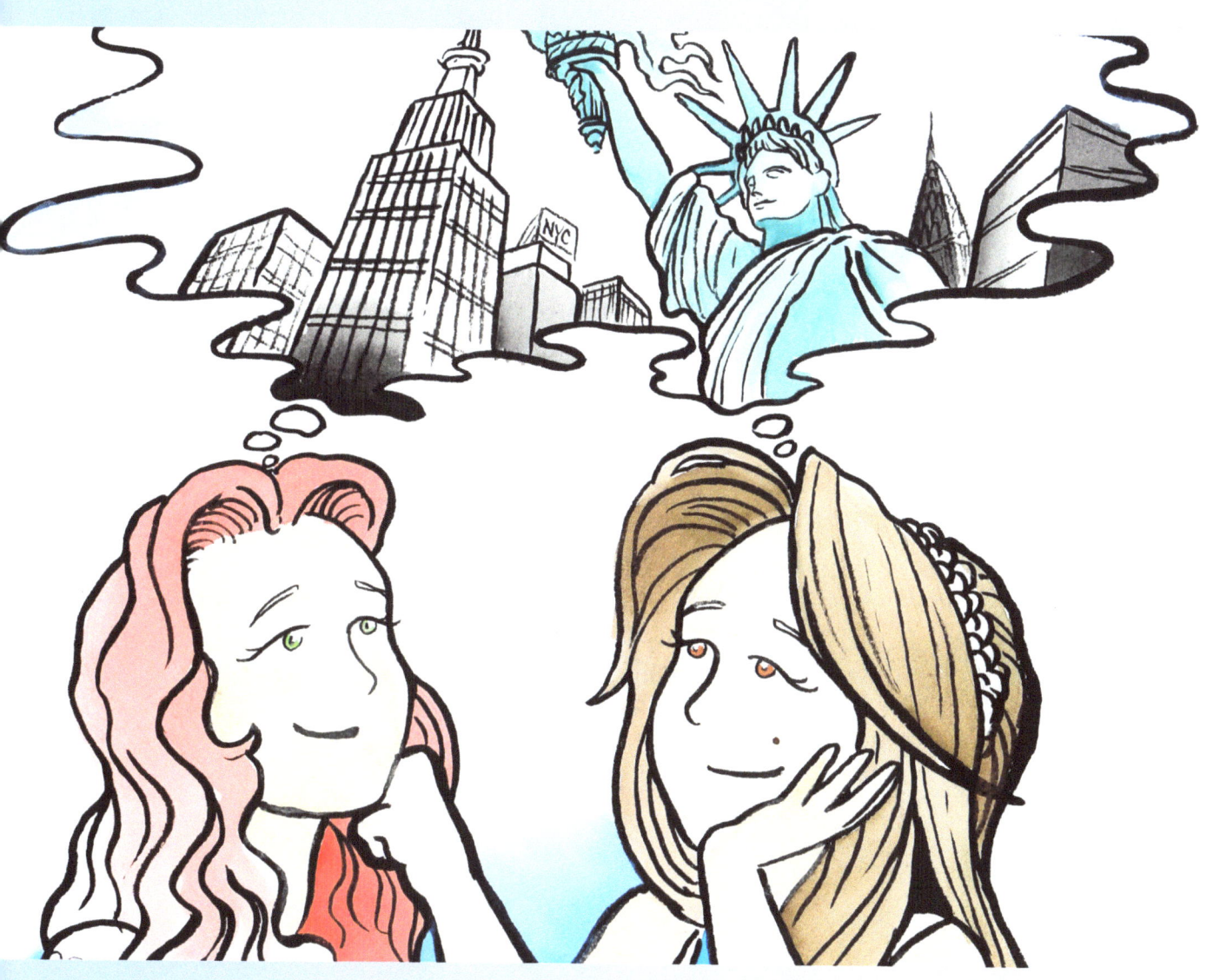

Ms. Simone says, "Your paintings, would have made Renoir smile.

Impressionist art works, in your very own style.

We'll put it all up beside Mays's poetry,

All five beautiful...and perfectly WACKADOEY!"

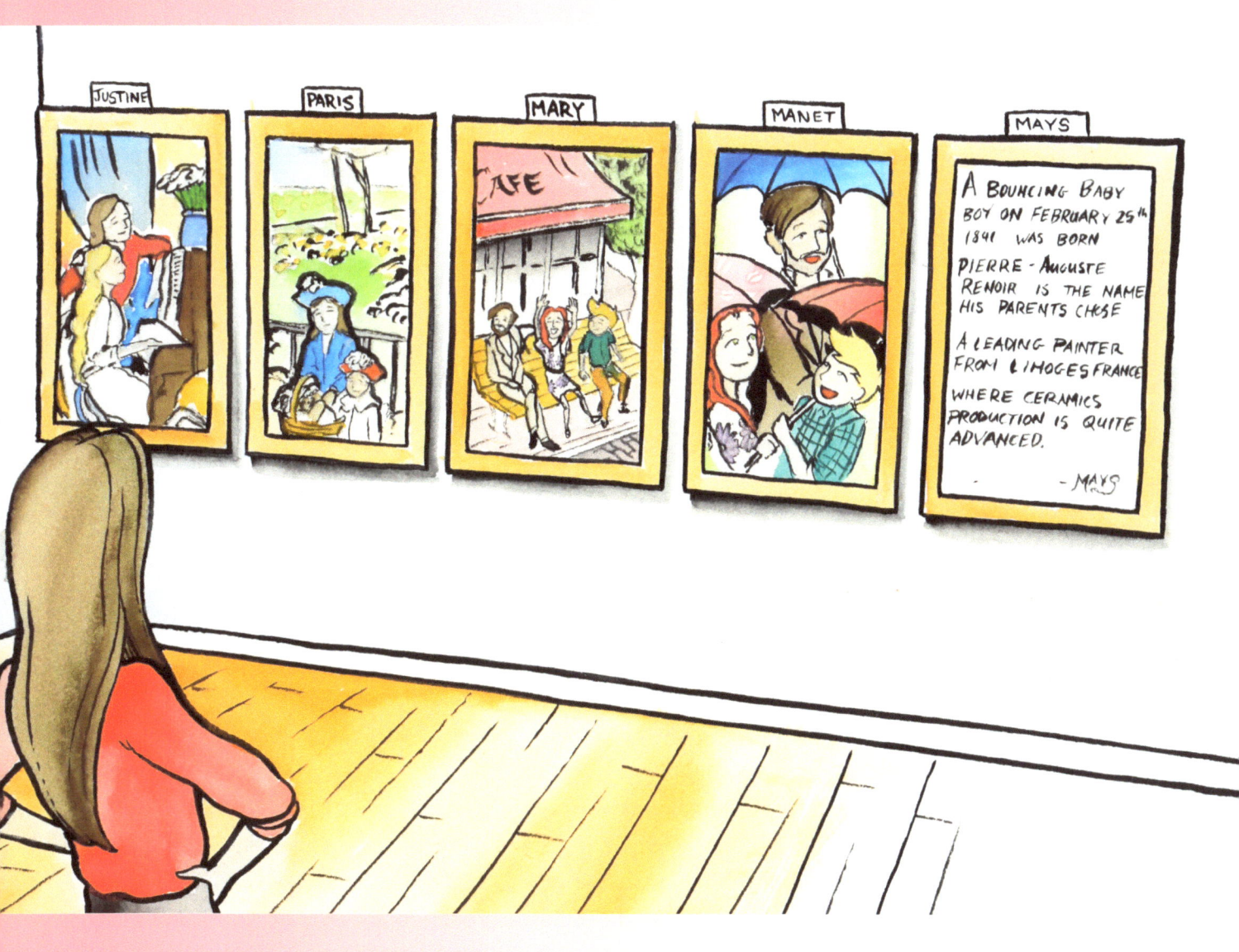

ABOUT THE AUTHOR

I was born in Tel Aviv, Israel and moved with my family to New York when I was eight.

I studied economics and sociology at Queens College in New York, followed by an internship at Lehman Hutton on Wall Street. (Yes, even investing can be creative!) As a buyer and merchandiser for Le Firme and later for Akris's at Bergdorf Goodman in New York City, I returned to my more creative passions.

I teach and co-run an art program called "Learning to Look" at the Schechter Day School. I introduced MAW to Cohen's Medical Center and have the absolute joy of watching children immersed in art, being able to forget their pain and their illnesses – even if just for two hours. Watching them experience their own "imaginative ways" impresses in me the power of creativity and artistic expression. Art helps children use both sides of their brains, embracing expression and imagination to create something wonderful. Studying art helps children understand the connections, shapes, colors and ideas that exist in every artist's work.

Teaching art history to youngsters in a way that encourages their creativity and interests rather than being intimidating (or boring!) is what inspires me to teach. The love I have for seeing their eyes brighten and their ideas form is what motivated the creation of MAW and its series of art history books, teachers' curriculums, coloring books, songs and online projects.

Paris, Manet, Mary, Mays, Justine and Ms. Simone all derive from my wish to bring the gifts of imagination, music, fun and facts to children. My own daughter with the same name inspired the character of Paris. The rest of the MAW kids were inspired by my boys Jordan and Logan, as well as the children that I have watched learn and grow while teaching them about art and creativity.

Ms. Simone is a reflection of how I teach and display art throughout the classroom. I want children to be able to experience art history in a way that inspires them to begin their own creations. All children (and adults too!) should have the experience of being told "Great job," "You can do it," and "Aren't you awesome?" Making art gives children just that opportunity: to express, learn and feel a sense of accomplishment.

Charitable work is a central part of my life. I am a member of the Women's Health Committee at Katz Women's Hospital; a member of the Autism Committee on Long Island; am involved at Sunrise Day Camp, a camp dedicated to children with cancer; and am a member of the UJA-Federation.

I enjoy spending time with my husband and children. Most nights, when all are asleep, I can be found sitting at the computer dreaming about the next adventure for my six characters, I now call family.

Have a fun and wackadoey experience!

Sima Levy

www.ingramcontent.com/pod-product-compliance
Lightning Source LLC
Chambersburg PA
CBHW050836180526
45159CB00004B/1919